Her book

Do not let your
heart wither

also by éireann lorsung

Music for Landing Planes By

Her book

poems

éireann lorsung

MILKWEED EDITIONS

Published 2013 by Milkweed Editions
Printed in the United States of America
Cover design by Gretchen Achilles/Wavetrap Design
Cover art © Kiki Smith and Universal Limited Art Editions, Inc.
Author photo by Jonathan Vanhaelst
13 14 15 16 17 5 4 3 2 1
FIRST EDITION

Milkweed Editions, an independent nonprofit publisher, gratefully acknowledges sustaining support from the Bush Foundation; the Patrick and Aimee Butler Foundation; the Dougherty Family Foundation; the Driscoll Foundation; the Jerome Foundation; the Lindquist & Vennum Foundation; the McKnight Foundation; the voters of Minnesota through a Minnesota State Arts Board Operating Support grant, thanks to a legislative appropriation from the arts and cultural heritage fund, and a grant from the Wells Fargo Foundation Minnesota; the National Endowment for the Arts; the Target Foundation; and other generous contributions from foundations, corporations, and individuals. For a full listing of Milkweed Editions supporters, please visit www.milkweed.org.

Library of Congress Cataloging-in-Publication Data

Lorsung, Éireann, 1980-
[Poems. Selections]
Her book : poems / Éireann Lorsung.—First edition.
 pages cm
ISBN 978-1-57131-433-8 (alk. paper)
I. Title.
PS3612.O77H47 2013 2012042168
811'.6—dc23

Milkweed Editions is committed to ecological stewardship. We strive to align our book production practices with this principle, and to reduce the impact of our operations in the environment. We are a member of the Green Press Initiative, a nonprofit coalition of publishers, manufacturers, and authors working to protect the world's endangered forests and conserve natural resources. *Her book* was printed on acid-free 30% postconsumer-waste paper by Versa Press, Inc.

for Z.C.L.C., S.Y. & L.D.

Contents

3. *Reconstruction*

Her book

1.

Fifteen poems
for Kiki Smith

Revelation

after Kiki Smith

From inside all this hair I can see you.

The body on the ground,
on its own, is resurrection. Female,

that's a question of creation.

Some days hair is miles of messages
meant for pre-Morse receivers,

bare scratching of another's hand

on vellum that looks like skin.
The body inside the hair room is

speaking like most other bodies;

its speech packs around it like wasp
paper. Speaking a thin, permanent

archive. What we call a woman.

Carrier (standing woman carrying wolf)

after Kiki Smith

She was preaching no sermon except

the one that goes love thyself, sinner, and love
them animals, the ones running past you

in the night when you can hardly breathe

their fur gets so close and all you want to do
is pass out so you don't remember how good

they smell and if you want to be one.

Standing

after Kiki Smith

From up here I can see it all.
Collision of the cellular level and the structures.

I raised this body myself.
I have been pouring water from my hands.

Listen, the body
is more like stars than we know; I've seen them

rising from my sternum, a private 3-D
panoramic constellation.

With my long spine I look down over everything.
With my bare head and my secondary stars.

, do it,

To go and live inside the wolf

and walk out one day, rip
its soft abdomen

open and leave

the carcass there like a casting.
Truth is,

we fought this—

we wore one another under
our nails for weeks.

We know what it's like

to stay where things are mostly
made of blood.

We know the soft

wet feeling walking in.
We know

where to slice to get away.

Untitled (camera)

after Kiki Smith

No one thought

to equip us for being
here. So we've been busy

making us things.

The camera's
a third eye

made of leather,

wood, oil paint,
one nail.

What's not to love about this

kind of looking?
Our homemade camera

sees with the densest eye

even
when we don't open its case.

Girl with chain

after Kiki Smith

Girl with part in her hair.

Girl with downward glance.
Girl with tiny Adam's apple.

Girl with shoulders gently.

Girl with generalized flower pattern.
Girl with stomacher.

Girl with late 18th century.

Girl with exposed.
Girl with blue ground.

Girl with fog.

Girl with platemark.
Girl with fourteen doubles.

Girl with Hahnemühle.

Girl with mottling.
Girl with linen, lines.

It falls into ruin by its own weight

after Kiki Smith

Let's punish all those women.

Let's punish them hard.
Let's make it so their babies

fall out of them

like red splotches
and their bodies are open

to whatever invasion we choose.

Let's show those women
they can't be trusted

with the frangible innards

we've taken so much time
to cultivate.

Let's haul out of them bodies

what we came for,
new stock, new

civilization.

Scaffold body

after Kiki Smith

We were used to living
attached to the ground.

So it was a surprise

to see others living
in suspension.

Bodies soft

as sunflower heads after
winter, hanging

from the scaffold.

We climbed on up.
The thought of bodies

even small ones

or ones we don't know
living like that

alone

was too much. Lying
on the scaffold's bars

our breath went in and out.

Our lungs moved
everything gently.

Swing, little soft

bodies,
swing.

Daughters

after Kiki Smith

You know what I learned in the dark?

First the body gets terrified.
Next morning, sun comes up.

The bodies of women are kneeling or prostrate

in the dark, bodies of women and children
fading like oil on cloth. Communion

of bodies, communion of votives.

A flickering taught me.
What we said there was:

the choice of fear

or love is *our*
survival, daughters. With our headless

bodies and our tracts outlined

by a doctor's lamp. The ones
who terrified us, we'll leave them

behind. We weren't talking

about them when we said it,
fear or love.

Dowry cloth

after Kiki Smith

Everyone who's uncomfortable,

raise your hand.
Such a cloth should make you happy,

don't you think?

We made this cloth from our skins.
We pulled out our own hair carefully

from the roots

and threaded needles with it,
we took the left-over, the uneaten,

the throw-away, the heretical,

the disgusting, the idolatrous, the dregs,
detritus, dross, the junk no one

but us would want, we took that

and our hard labor
and our bodies

and made you this.

Honey brain

after Kiki Smith

Ask what this is,
if you don't know.

I'll tell you: the honey

brain is part of some
of us, sitting up there

dripping

every day, sending sticky
sweet bee-made

pulses to the body, saying

body,
listen,

saying

body,
you are not salty

sour, bitter,

body, you are pleasing
in general, saying

body,

aromatic, perfumed, soft,
rich, lyrical,

wholesome,

agreeable, good, charming,
lovely,

full of delight.

The cells—the moon

after Kiki Smith

SHE CAME IN A BODY THROUGH A HOLE
THE CELLS
THE MOON RATTLED INSIDE HER
 FREQUENTLY

Things in the body made of iron, for instance.
In between marks, the space of the body.
The moon is part of the body when it comes out
 in the sky and drifts through it,

the arc of the moon is the body's arc.

In the body are the shapes of the cells she can name,
 blastocysts.
Her breakable and lacelike handmade cells.

Familiars
AFTER KIKI SMITH

A most natural complement
for female bodies
—
the bodies of animals.
—
We have found ourselves
safer
—
with cats, dogs, pigs, rabbits
—
guinea pigs, goats
sheep, donkeys,
—
mice, rats, squirrels,
—
than with those other bodies
in almost every telling.
—
Your fables
—
our story
In the depths of winter

18

Stars and scat

after Kiki Smith

We're talking basics here,
just questions of inside and outside.

When it comes

down to it, the sky
is full of bullshit, a few thousand

years of the stuff:

women chained to rocks, heroes
swinging their clubs

all over the universe.

Listen, we know
the sky at this time of night is *pret-ty*

and makes you prone

to stories you'll recover from
like a millennial hangover

but look closely

we went out, and it was snowing

We went out
in the snow, in the night

the wide unknowing

darkness of December
with candles, our bodies

the familiar animals

the ones we loved. We can say now
we never felt afraid

in our wool dresses,
tracks of hooves & paws
around us. The snow.

In light like that all our bodies

burnt brighter and brighter.
Someone else's tale: became stars

at the human body decomposing
from the inside

out and then at those indifferent stars

and tell us: who exactly
do you think you make those stories for?

Blue blanket

after Kiki Smith

For the gentlest hour

we made this blanket.
See the pattern: butterflies.

Marguerites.

The most secret things.
We are to touch it

with a single finger or let

it cover our bodies
like afternoon.

2.

Girllife

First principles

In the beginning was the labyrinth.

It was the size of a continent, the inside
of a jar she carried in her shoulder
bag, swinging while she walked.

Sometimes she didn't know it was there
but underneath everything walls
would rise, hold
up construction of new roads, and
she would reknow: it was there, she
had seen it. The labyrinth covered

everything in questions.
It opened windows to the sea
where no sea should have been.
She entered it daily:

she never wore a watch, she carried
Nothing with her, or she carried
her knitting, she emptied
the canvas bag at every turn
and filled it
 with sand, guitar
strings, replicas of Machu Picchu
and Neruda's house. Nothing

was enough. The labyrinth
followed her from one edge
of the world to another.
It was all around her, like her mother's love.
Every morning she reentered
the labyrinth from the labyrinth.
The smell of the sea that wasn't there.
The clicking shadows of laurel trees
and their scent; she was full
without eating. Outside
were shores and straw
boats and the ends of strings leading
from the center. The jar
she carried was lighter
and lighter as the labyrinth went out into the world.

Historical fragment

She began to find playing cards everywhere and so she took to looking for the ones she liked best (the Queen of Hearts, the Ace of Hearts). She found cards with dotted designs, cards prisoners had drawn by hand, Bicycle cards, pinochle cards, cards from airline passengers' handbags, cards given out by realtors as mnemonics for the houses they tried to sell. She found several cards from the 1700s. She rarely had to look for them: they were stuck in hedges, strewn across otherwise tidy front lawns. Early in the morning she would walk out of the little brick house and there would be one lying on the pavement or floating innocently down from the chess-queen chimney pots. No one seemed to miss the cards she took. They were all playing with full decks.

Pink

for Sriparna

Everything turning

to fuchsias
 hanging over stone walls

a deep, bright color, eight stamens

dianthus, stitchwort,
the smell of cinnamon

the inside of a kimono
a surprise of cherry blossoms
 & shibori

sweetshop's matching jars
of rhubarb-custard candy
mica-flecked dust for eyelids—

 crushing
petals in a pocket
was like blushing—

She wanted to touch everything
over & over

A collection of beauties at the height of their popularity

for Mulysa

Ghosts
like young hazelnuts, lichen
trailing from trees, checker
lilies, white
columbine that gets too
little sun.

A park in the middle
of a city, a mile,
a fairy tale.

Here are two girls
with round fans
rabbits on leashes
striped socks
one glimpse of eyelet
wool that scratches.

And you have a collar
I love, red dots
& yellow dots, a gray field.

My egg-blue dress,
your chartreuse sweater,
satin hairbow.

Piles of thread, cuttings,
velvet nap rubbed
back with a hand,
corner of moon in an upstairs window.

And so the last day came, and the last hour of the last day

for Shani

Our dreams of snow—

It was as though we were on a ship
in the middle of the prairie

It was as though the house
was sighing or breathing

Stocks of flower seed, vegetable seed,
wool blankets, quilts our mothers made,

pressed leaves, books of poems, tea
in packets, sugar flavored

with petals, paper birds and animals
with pin joints, scissors, glue,

paints, teacups, colored shoes, a pile
of silk scraps.

The most gentle apocalypse in the world

We woke up, the sky was blue.

Bee summer

The basement room
lined with sun

full summer
green

When clover is
bees are

Air & pollen in the lung

Bees will always be there
wild rose pinkening outside

and now
even in winter

there is no winter

City pleasure

It sweetens everything:
 a busker's movement, A chord to C chord,
 Porte de Saint-Ouen, the first heady rush of cars, gray lifting off the city.

If you have never been to Paris, go there
 in November, wear a heavy scarf printed with shibori, wear
 an overcoat.
 Walk along the Seine, past booksellers, souvenir
 shops, women wearing red, and Notre Dame.

The RER through Saint-Denis.

Sitting near people you don't know, you will want to touch them.
 Your body will hold itself from touching them.

Leaves from plane trees yellow in the gutter.
 In Montmartre, the same leaves yellow against sky.

 —I love what I love for what I know's inside.

England, or the continent I had in mind when I came here

for Caroline

Every bird is a sister of mine—can you believe
I never saw horses running
 before I came to this island,
and nothing but their own good sense keeps them
from falling into the ocean?
 At the edge of your country
 along train tracks that run from Devon
to Cornwall, someone
 set up a howl and it's been going
 longer than we remember,
 or our mothers
remember, or their mothers.
Where else could a woman turn
into flowering rosebush? All
so peripheral, the crooked edges maps show—
 the limit is sensate here
 where I can never travel all night
and the next day—
 I brought you what has bound you,
a piece of cloth in tatting thread and colors
I found here—loosestrife, sorrel, the guelder rose,
wood anemone—a tapestry
 barring girlhood to one
field, long stripe of a neighbor's plow turning
land just over the woven branches: earth
to earth.

The sandwich cart rattles by, you stack
cups on a tray. Meanwhile, unobtrusively, the air
diffuses particles, the sky is pinked.

 This earth.

 This shining in the sea.

Sweets

for Kezia, Emilse, Caroline, Adity & Eva

In the high windows, contrails; a severely English blue.
There were trees growing out of buildings.

We could touch one another's shoulders and we did.
Flowers on our desks in old jars, postcards,

pictures, poems, biscuits, cups of tea, train trips
on a Saturday,

ridiculous photographs, sleep, poses
in government-regulation photobooths

with masks on—
we knew nothing had to happen.

: :

The tracks of shore birds were a cloth no one
had woven and we couldn't name.

We made a text with the passage of our hands.
We were near each other with music and in silence.

There were rarely places we could be at home.

Although we missed where we were born.
Although dispersal was the ultimate answer.

We held hands, borrowed clothes, sat together, watched
for stars or hot-air balloons, birds, satellites.

Did not expect them. There they were.

Live bees

for Carol & Pippa

The honey stinks
of thyme

& I've forgotten what I came here for:

storeroom's new moon, cusp
of night, summer, or something

raw & lonesome?

There's animals in places they don't go.
There's a heart in my body

wanting a workshop to walk into

& smell the air.
A woman lay back on her couch & wrote,

μελιφῶνος.

Long ago we walked into orchards
bearing unexpected fruit

—kept *honey, bees, orange grove,*

evergreen, aromatic,
all her remains.

The birdwoman at Grasmere

for Polly

A woman's book documents her intense response to nature. Swallows fly through a house in the summer. She walks. Green begins, and stone walls. In Repton a monarchy decomposing. Catacombs below a village: she above. Now through fog fields appear. *And I in a world where everything is mine.* Lakes appear. These are pearls that were? she wonders. A rope bridge, an arc, *the unutterable darkness of the sky.* Hands that carry water make no demands on her; hands that carry wood. Every lintel she crosses, she touches. What she touches echoes back.

Smooth stone, fox

There was one smooth stone she kept turning over in her hands
There were mottled marks on the stone
 & it rang in bright sharp tones with mica

Where her hands had been was the stone
 & the water the stone came from

In the night she was walking through rows of terraced houses
 & the fox ran between houses, out of her sight

The fox watching her walking
 The stone's invisible, insensible eye

Light from the streetlamps, closed shop windows' rough glow
 The night smelled of uprooted lavender

Everywhere she walked the fox was following
Across the parking lot its white breast, its padding feet, stranger

than a cat's movement, its swayful tail—

 if the fox were gone it would only be me
 & the stone in the world—

How it all began

We were afraid we would never run again,
so we set off running down the road.

The shadow of a semi jumping fences like a deer ahead of her.
The edges of fences alternating bright / dark in the way that hewn lumber does.
The corn ripening almost so she could hear it.

Yes, in the past I have seen the magpie alight on a rail
have passed through the ridged valleys
their tinfoil graveyards & their plastic flowers

the cacti lying as though killed
the burnt-out riverbeds and the tumbleweed
& the scratch in the sky

If there was something broken, all that time it was just our heart.

Nothing to do but to say the old prayers,
larch, maple, oak, tawny aspen, birch & scrub pine, tamarack, linden, elm.

In the distance, a few weak clouds.
As far as telling the future, a farm for sale with phone number.
The sisters waiting on the other end of the road:

Who doesn't think we can run anymore?

In the ninety-degree afternoon were brown cows & cows that were black with white faces.
The cones of the yellow wildflowers and the road cones unnatural orange.
The plains cradle rocking into the ninth month, the midway point, Nebraska,
towns sprouting in the middle of prairie, fireworks, fast food, gasoline—
everything waiting atinder in that final September blaze—

She did not believe.

So I was set to see the country.

In the end of the rein rode the red & black wingspan:

Town forgotten, petticoats over my head,
if there's one thing I learned the train
& the deep voice of thunder is all of it

We bore down through New Mexico together;
she was drinking oil from the second car.

Nothing alive in the desert but the winking eye of the lizard.
Birth of rocks from glacier. Same winking in the rocks.

> Sometimes prayers don't exist to save us.
> What boils up is bile, pure and simple.

> One of these days the running will overtake us. Sure of it.

> But hey, here we are in the center of things,
> our legs working just like pistons. Where are our grandmothers?

> We have carried your books and your likenesses, we took them
> when we broke the first boards with our browning feet and began to run:

> windmill our hair made, the way the daylight lifted everything up
> in the world, the roads and the roads and the wild old roads.

Historical fragment

The year the fish weirs were removed from the River Thames and the River Medway and throughout the whole of England she was wandering slowly and on foot through the hills. She hardly noticed the number of fish that were saved, she passed nearly every day counting only those things that flew, walked upon the earth, or burrowed into it. Avon, Trent, Soar, Severn, Usk, Nene, Ouse, Weaver. Underfoot, she felt everything moving away from her. She had forgotten what swam.

The birdwoman in the cathedral

Here's what I can muster. A certain treatment of material things. *I mean a remembrance of the way human hands were and what they touched.* Talking about wax, glass, wood, paper, lead, stone, gold. Talking about milk. Honey. Blood. Light coming from high up and coating us. Necklaces of clear beads. A certain way of counting things in order. Paper collars, red votive lights, beneficence; crowns made of stars, arrows, gilt, roses; soft palms; the word *yes*; a door that opens once and for all.

International postage coupon

for Alyson

(I received your communiqué

 speaking of elephants
 on their knees in some invisible
 savannah

 the death of stars)

We are alone
 in the universe, you
 said, *in bags*
 of skin, millions of miles

between atoms
 there is only beauty
 to touch us
 it survives voyages
 no test animal could make

We send it occasionally: photographs
 of women praying in cathedrals, ear's fine-haired edge.

(How
 this body is a galaxy to what's inside it)

Bird construction

for Shana

I've been making songbirds out of paper & leaving them on windowsills, bodies barely warm. The construction of a bird requires a pair of sharp small scissors, twelve cakes of watercolor (yellow worn into a ring), gray light preceding thunderstorms, music with almost no sounds to it, a wide & stable surface, a tin brooch shaped like a pansy, an atlas covering four thousand miles, selections of feathers in a hexagonal jar, the shape of the bird itself, fifteen minutes of quick conversation after months of silence.

Honey

for Laressa

First print the cloth with jasmine
drawn on this screen, white

flowers on a pale purple field.
We're going to the hives

tonight, we'll wrap
jars & comb in the cloths

we make. Bees
take pollen from acacia

from orange
from rosemary

from clover
from viburnum

from quince,
bees less bitter and more astute

than their keepers.
We're going to steal, bend wires

down around the beeyard,
lift those hay-frame boxes.

We're going
with our bodies

full of something sweet
like honey, something radiant.

.

3.

Reconstruction

Autoportrait tree

Red skin of the bough and its wax
leaves, fruit first-leaf green. They ripen
also to red.

Horribly so, horribly so.

Knot on a belt
Knot on a valise

We were on a journey without
the female names for things.

Decamp, betake, retreat, push off,
skedaddle.

Places we got those names mobile.
Aromatic.

We have been indigestible,
covering ourselves.
The fruit that can't be eaten.

Our books are a floor of smoldering ash

One hundred and fifty stitches
one second of contact with human skin.

Within all of this, something of a
British Library.
Orchard a remembrance of mahogany
somewhere.

Memory of green lampshades. Memory's
pen moving
across baize, wove or laid paper, breviary,
ledger.

Where in this world are the branches
flowering in glass jars?

I'm saying, where are the living
things?

Post

The letter arrived after waiting for it.
By letter we mean a drawing folded in half.
We watched it uncrease.

By drawing we mean a woman lying on the floor.
We've been believing in the posts so long it's second nature now.
Days go through us without a single doubt.

Airmail, that's the future speed.
Have you noticed how uncertain some addresses feel these days?
Ignore that.

Go and see if there's nothing in the mail.

Think on the lilies of the field

for Sue Peng

While walking to the grocery store and walking home with bags containing pears, oranges, tomatoes, a packet of rocket, leeks, parsnips, a couple of zucchini, a small cup of heavy cream, a punnet of shrimp, basil growing in a pot, organic chicken thighs (skin on, bones in), a carton of orange juice with bits, two pints of milk, toilet paper, a half-size bottle of Chablis, a box of sea salt, a jar of Kalamata olives, two Tetra Pak boxes of black beans, a can of corn, four cans of tomatoes (chopped), six eggs, flour, fresh yeast (25 g), box of Cheerios, house-brand gingersnaps, your same old daily smock fraying at the armholes and patched inside, where a button came off, with bright fuchsia, shibori-dyed silk.

Listening to other people's praying

Sister I can feel your voices through the floor.

<div style="text-align: right">(These are the destroyed mills)</div>

I have emigrated backward
 away from your plans
into the smaller realms a gesture in transmission

Sister your migration takes place in the body
my migration takes place in the body

Your face seems to want to hum
You are almost invisible to memory
 Everything is work these days
 Is that you singing in the distance?

<div style="text-align: right">(The boats that were there are
submerged and the dock that was there
is submerged, the house was left empty,
the house was destroyed, the windows
blew in and out in the heat)</div>

The cross-breezes agree, there is no life left in central Minnesota.

The floor was a seven-pointed star: inlaid parquet.
A carpenter went crazy building that floor.

The here shakes with prayers—
Mostly the feeling of your voices moving through me.

(How to treat your photographs, your recordings, your papers, your books, your old shoes, your eyeglasses, your costume jewelry, your wedding ring, your gold tooth, your medicine bottles, your visions, your tools,

My things are a city I cannot forget
which does not forget me

your homestead, your ceaseless travel, the grain fields you've seen on another continent, radioactivity shearing the heads from wheat, a plane barely able to outrun the bomb it drops, a record of every scar on the one you love, a vaccination, the land turned under a spade, a house with wool blankets and wood floors, a final escape from damp, maps without holes, postcards and old photographs, memory of voices)

62

<div align="center">or the voices?</div>

When I was a little girl the house would always be there.

Once it was abandoned people tagged inside it,
not even beautifully.

I thought I could rescue everything by writing it down
 taking photographs

I threw all my records of that time away
migrating
 cleanly
among continents

 (No doubt
 in my impeccable heart)

Even the newest garden is my memory
of tomatoes growing wild in August

their smell on my hands on the back step

 The gray steps
 of the white-sided house

 salt

I want photographs
 (and want to tell you this)
I still don't understand the life I lost
I sometimes forget it

I feel so comfortable and sure
even though things will always die and disappear

And still I want to record it
 (pray for us)

 (nothing, not enough)

 (first yellow, then the sky)

Creation tune

for Vanessa

I bring the days with rain. I bring the deaths' heads. I bring
the gourds on vine. I bring a guitar to the grass. I bring
gardens out of silence. I bring a needle.

In the garden the history of corn.
In every vessel a remnant of salt.

The noise of a great migration.
The shape of birds against a window.

The poem as memory of the garden.
The memory of the garden in the body.

Salt in the body turning to memory,
memory in the body turning to salt.

Needle threads the garden.
Over on the grass, window makes four squares of light.
Paper bird unfolds and folds itself.

One after another the rotting of the bodies.
Ash over hills, roads.
In the springtime everything grows a human flavor.

History here is rows of unused brushes.
The garden brings one hundred walls,
a hundred apples, blades, bricks, sheaves.

Sewing together

for Neele

If, sister, we sew together, your hand
darting like your hand. That's valuable.

We went to school and someone there
told us not to touch things, sing things,

dance things, hold things, love things.
But in fact we were singing together

while we sewed. We began sewing
parts we didn't use. My leg to your leg,

your left arm to my left arm. We sewed
together everything in us able to touch,

sing, dance, you know what I mean.
New body's grace was a shambles

but it spoke with us, fragments
of an original language.

Quilt with birds

We've been told the women who make quilts here have birds' heads.
The women carry their birds' heads through town like ordinary marketable goods.
The embarrassment when one's head starts singing uncontrollably.

Let me tell you, those aren't birds' heads.

In the left hands of the women there is a blue cloth.
In the right hands, a needle.
We can't see yet, maybe ever, if the needle's threaded.

This morning the town got dressed up for this.

The women's hands hurry over the cloth like flocks of starlings, changing shape.
It's hard to tell, are these women's hands or a flexible constellation
of dark shapes rising into the air above the quilt?

We leave our houses, we go to see them pierce the cloth

over and over, scourging it, yanking it, burying it under layers of stitches.
The women's heads keep up a low trill.
No, not like wood pigeons. These women are nothing like wood pigeons.

Eating the archive

I eat the archive, which used to have a flavor.
 The taste of the letters.
 The taste of what made them.

Tired as I am of people sucking
 and eating the spines of books
I eat it all.
Outside, the snow and candles.

Continue to eat it. Pages dry as old leaves.

Everything is dust in the archive.
The poem is dust.
My tongue is coated in it.
Touch is what makes the archive disappear.

Under the snow lie ghosts of railways,
a city surrounding
everything.

Things in the archive and city
are going to die. Tonight
they begin to fall apart.

I hold a candle, blow it out. Eat it.
For the first time, the people outside
are sleeping. Quiet.

> Where no one is chewing.
> Where no one is licking and licking their words.

Single-page drawing

for Laressa

Accomplished by the togetherness of things,

Includes:

movement of the poem a movement of marks.

red-and-white,
pink-and-white gingham

matchbox of sequins
In the center of the room the typewriter (multicolored)

hangs a new sheet every time you look at it

jar of ink, label
we're talking about the sending & receipt says Radiant
of messages in disappearing ink says Cerise
says Bien
Today there is the character 命 Agiter

the space around it in red ink faux-fly-agaric, tiny
mushroom in spun cotton

a picture of an iris

I smell sweet savors and I feel soft things

 champagne cork
shooting star
on the hidden side

printed variations on a leaf

In my dream my body
has always been female
whatever that means

 red-and-gold box
a pair of garnet earrings
a pair of hands

 an inside thing a pair of school doors
a pair of small French towns

 hair & teeth

The mark of my hand is a hand-shaped print.
Listen! I'm making these things to show you I was
here. The outline of *my* hand. *My* body. *My* dresses.
My law allows the entry of things scarred by their
own softness: peonies, rainfall in summer. A bone
 is enough to tell a true story.

Someone who wants you to believe the story
mostly happened in losing terms

 Doesn't necessarily want you to believe
how strong what you *feel* is

(trefoil, quatrefoil, cinquefoil, fuchsia,
cyclamen, lady's bower, pinks)

Belief?

(foil wrappers, cherry-blossom
prints on paper)

.

We made a minute study
for years

of other women's habits

beeswax lump
tea leaves

hearts ease
lamb's lettuce

—that's the interval between February and April.

In this box,

twelve old cakes of watercolor
chipped bowl printed with blue flowers

airmail stickers
判子

And then them things I love,
that blood

just hurtlet right out a me

I learned from you, I learned this from you.

Transubstantiation

for Shana

In Iowa she sits down at the table.

First, take your plate and coat it with asphaltum

A season of movement is punctuated by a green smock
a red smock

We took all the chairs out of the house. That was upsetting.

The point of the needle just *through the coating*

electric current copper plate
 ink dauber steel needle
 Dutch mordant wax

A copper atmosphere,
acid room,
heat, suction, ventilation:
the one substance goes secretly to work on the other.

Smell of the bath
If you prefer, red ink

Hand-sized bundle of rags called a dolly.

Kiss of a red print & her green smock

Nothing magical about the image
appearing

In the space that contains all missing objects—

We've talked about ink tack, knives, variable
pressure, heating
the plate or not, dampening the paper, mulberry
versus cotton

The table, plate, body, hands, needle
in Iowa
Smock is a kiss for the body like the press
for the plate

Funny how clearly the body can be seen even at a distance
Even over water

What do I do now?
—You touch
it with your hand.

And now?
—You find
marks that appear
without preview.

And now?
—You wait
alone / not alone
in the twinned
printshop

Acknowledgments

Grateful acknowledgment is made to those publications which first made a place for some of these poems, sometimes in very different forms:

"Rapture" in *Quarterly West*
"Carrier (standing woman carrying wolf)" in *Bateau Press*
Both "Historical fragment" poems in *dislocate*
"And so the last day came . . ." in *Barrelhouse*
"International postage coupon" in *Diode*
"Smooth stone, fox" in *Caffeine Destiny*
"Scaffold body" in *Konundrum Engine Literary Review*
"First principles" in *Cerise Press*
"Quilt with birds" and "Standing" in *Midway Journal*
"The birdwoman at Grasmere" and "The cells—the moon" in *The Pinch*

"England, or the continent . . ." and "Honey" each won a Dorothy Sargent Rosenberg Prize.

All the poems in the first section use titles from work by the artist Kiki Smith.
"The cells—the moon" contains words from Kiki Smith's sculpture of the same title.
"The birdwoman at Grasmere" contains lines from Dorothy Wordsworth's journal.
"Live bees" contains fragment 185 by Sappho.
"Single-page drawing" contains a line from Shakespeare.

Special thanks are due to those women who supported and inspired me, this book, and my writing during my time in England: Liadan McKiernan, Nuala Rosensteel, Neele Dellschaft, Carol Rowntree Jones, Pippa Hennessy, Donatella Coleman, Sue Peng Ng, Sriparna Ray, Anna König, Jeanette Bunyan, Melissa Shani Brown, Caroline Edwards, Emilse Hidalgo, Adity Singh, Eva Giraud, Kezia Picard, Alyson Sinclair, Vanessa Ramos, Laressa Dickey, Shana Youngdahl.

Many thanks to Jim Cihlar, who shepherded this book from the first.

Éireann Lorsung's first book, *Music for Landing Planes By*, was published by Milkweed Editions in 2007. A Minnesota native, she has lived in France, the UK, and Belgium. Lorsung edits the journal *1110* and co-runs MIEL, a small press.

Interior design and typesetting
by Gretchen Achilles/Wavetrap Design
Typeset in Adobe Garamond Pro